ıest r

This book i

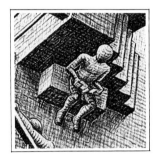

THE LIFE AND WORKS OF
ESCHER®

Miranda Fellows

SIENA

The Life and Works of Maurits Cornelis Escher

This edition first published in Great Britain in 1995 by
Parragon Book Service Limited
Units 13-17 Avonbridge Industrial Estate
Atlantic Road
Avonmouth
Bristol BS11 9QD

ISBN 0-7525-1175-0

Printed in Italy

Editors:	Barbara Horn, Alexa Stace, Alison Stace, Tucker Slingsby Ltd and Jennifer Warner
Designers:	Robert Mathias • Pedro Prá-Lopez, Kingfisher Design Services
Typesetting/DTP:	Frances Prá-Lopez, Kingfisher Design Services
Picture Research:	Kathy Lockley

MAURITS CORNELIS ESCHER 1898–1972

Escher was an unusual artist, driven by a desire to solve problems which may seem more relevant to the mathematician than the printmaker: a desire to expand the artistic limitations of the flat surface upon which he worked. Artists have been creating the illusion of depth on a flat surface (be it on paper, canvas or board), since Giotto first demonstrated the practice of foreshortening in the 14th century. But the Renaissance principles which developed as a result did not go far enough for this 'alchemist'. These principles were closely linked to the position of the horizon line and, even though they embraced vertical perspective, it was kept in its simplest form. Escher was interested in examining the potential of vertical perpectives, creating greater depth and multiple viewpoints within one image, sometimes producing more than one vanishing point in a picture. He wanted to prove that the two-dimensional surface was capable of greater illusions of depth than had previously been shown.

Escher strove to achieve the impression of limitless space, to explore the transformation of one world into another, or others. Often we can follow the transformations as they occur and believe them, even though rationally we know they are impossible. Escher never rejected the representational in his work, so there is always an access point for the viewer. Once inside the image, however, the safety net is removed. Entering one of Escher's prints is like entering another world, where all our solid foundations are shaken and replaced by a new set of spatial dimensions. Motifs which frequently appear include fish, lizards, birds, sea and landscapes, at times reflected in water or mirrors. Escher sought subjects which he could pare down to their most simple, two-dimensional forms and then transform into solid, three-dimensional objects. He also chose subjects which could easily metamorphose into something else – fish into birds, for example. When approaching such works, it is best to suspend disbelief and join the artist

on a journey into a world where even gravity does not seem capable of keeping our feet on the ground.

Maurits Cornelis Escher (1898–1972) was the youngest son of a Dutch engineer. He was an artistic child, and attended the School of Architecture and Ornamental Design in Haarlem 1919–22. Halfway through his architecture studies, he decided that his real interest lay in graphic design. He changed courses and was trained under Jessurun de Mesquita, a master printmaker whose influence was recognised by Escher throughout his career. Mesquita taught the young student to appreciate different types and cuts of wood and, among other skills, to produce highly proficient woodcuts. For the next seven years Escher rarely employed any other technique, apart from pen and ink for sketching. In fact he did not make his first lithograph until 1920-1921 and his first wood-engraving in 1926, although both techniques were to become hallmarks of his mature style.

Escher belittled the prints he produced before 1935, in later life describing them as 'of little or no value now, because they were for the most part merely practice exercises'. But without them the later, more famous, prints might never have evolved. As this book charts, in the early works Escher set the foundations upon which his later, more imaginative art could be constructed.

During the years in Italy (1923–35), Escher drew much of his inspiration direct from nature, although even at this early stage his interest in perspective, unconventional viewpoints, minute detailing and somewhat surreal subjects was already surfacing. After 1935 he relied more on developing ideas which sprang from his imagination. This had much to do with a change of circumstances. Escher, his wife Jetta and their three children, left Rome for Switzerland in 1935. From there they moved to Brussels in 1938, and finally set up a permanent home in Holland from 1941. Without the southern climate, the architecture and landscape of Italy, Escher felt bereft of subject matter. He began to look inwards and discovered in his mind a new and even more potent source of inspiration than southern Italy. The fact that he could solve problems which were rooted in his mind in a visual form on paper, and so communicate them to the world, came as a revelation, opening up the floodgates of a most extraordinary and idiosyncratic art.

It has often been said that Escher's work holds more appeal for the scientist than the art-lover, that the basis of his examination into the functions of art and design lay in mathematics, even crystallography – a long way from aesthetics. Escher was aware of this criticism but it did not concern him. He realised that the audience for his work might not be a conventional, or even particularly artistic one, and said: 'Although I am absolutely without training or knowledge, I often seem to have more in common with mathematicians than my fellow artists.'

When Escher was asked to attend or speak at academic conferences on such subjects as applied mathematics, however, he found himself at a loss. He could only find the answers to his questions through visual experimentation, and it seemed that the specialists were more fascinated by his world than he was by theirs. Perhaps Escher is the only 20th century artist to have bridged the gap between art and science.

From 1941, Escher made many trips from Holland to Italy and he also visited the USA. During the 1950s he became internationally successful, with exhibitions in Washington DC, Italy and Holland. His work was published and criticised in Time, Life and other international journals, which all helped to fuel his reputation. He often complained that he did not have time to fulfil all his commissions, and resorted to putting up his prices in order to stem the flow of orders. This had no effect; his popularity continued to grow and he was knighted in 1955. During the 1960s the artist was forced to endure a series of operations and his health slowly deteriorated. But he had already produced a large body of work, to which he added during these later years.

Escher's art springs from a highly individual imagination, and yet it is dispassionate. Much of his output was black and white. He used colour only when strictly necessary, to create distinctions between forms, or to add further spatial qualities to a work, never solely for decoration. Like Chirico or Magritte, two of the great surrealist artists of the 20th century, the viewer often feels left utterly alone to engage with the subject. There is nothing of the artist in the image to welcome the viewer into his creation. Even when people appear in his prints, they are impersonal, and often seem to be in a trance-like state, dispossessed and disengaged from others around them, standing alone in the esoteric realms of their creator's silent world.

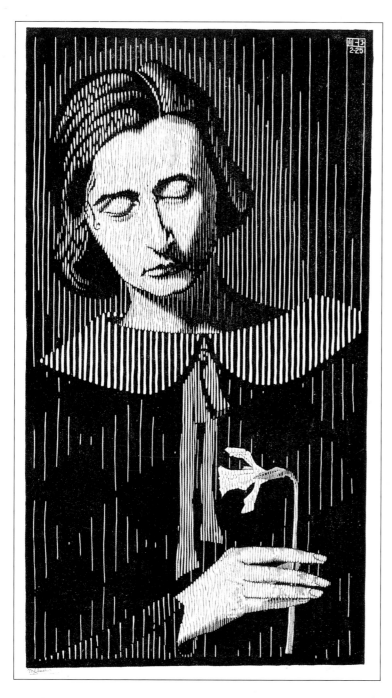

◁ **Portrait of Jetta** 1925
Woodcut

JETTA UMIKER CAPTURED ESCHER's heart when he met her in Ravello in 1923. She was the daughter of a German-Swiss industrialist and she and her family were passing the winter in Italy. They married in Viareggio in April, 1924, much against the wishes of Jetta's father, who was not enthusiastic about his daughter entering the Catholic church, which she did later in the same year. This woodcut of his wife was made by Escher in the winter of 1925. The couple were residing in Frascati at the time, while they waited for their new apartment in Rome to be completed. During the following two years Escher began to exhibit his work, having a series of successful shows in Holland and Italy. Jetta gave birth to two sons, George in 1926 and Arthur in 1928.

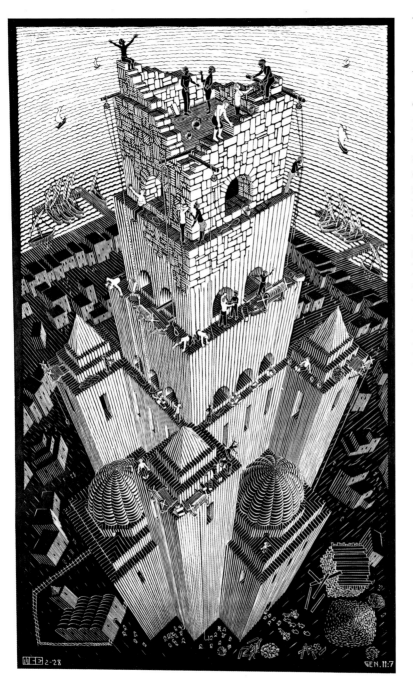

◁ **Tower of Babel** 1928
Woodcut

THIS IS A PIVOTAL WORK in Escher's early development, the unusually high viewpoint creating a vertiginous aerial perspective, a choice made not simply for aesthetic ends. On the subject Esher later wrote 'Some of the building workers are white and others black. The work is at a standstill because they are no longer able to understand each other. Seeing that the climax of the drama takes place at the summit of the tower which is under construction, the building has been shown from above as though from a bird's-eye view.' Escher's social comment runs far deeper than the local subject matter described – he was beginning to feel great anxiety at the emergence of Mussolini's Fascist party.

▷ **Castrovalva** 1930
Lithograph

ONE OF ESCHER'S FIRST lithographs, this print was also one of the earliest to bring him critical attention. In it, the stirrings of a lifelong obsession with the relationship between two and three-dimensional planes become apparent. He intentionally plays off different spatial dimensions against one another; intricate foreground detailing and form of flora and fauna against flat sloping plains, the slanted angularity of a walled city against soft, bulbous clouds. The image lacks emotion, its strength lying instead in the artist's intentional depersonalization of the image.

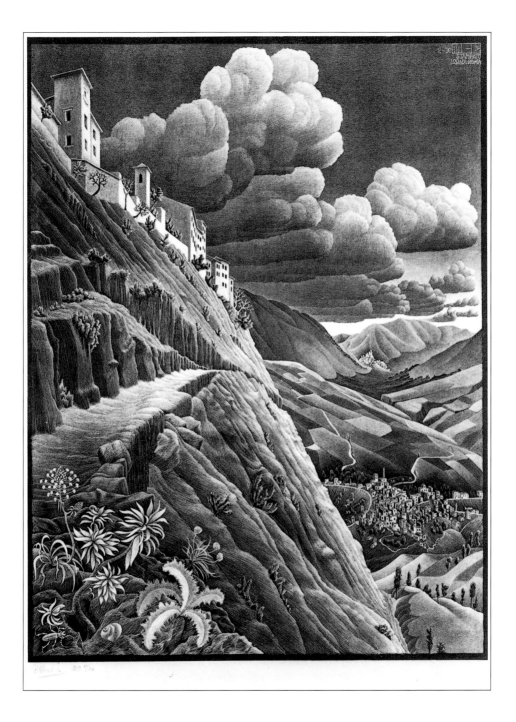

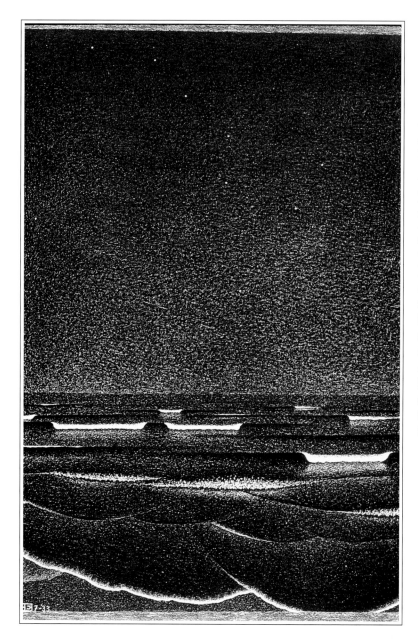

◁ **Phosphorescent Sea** 1933
Lithograph

BY 1933 ESCHER'S WORK was
selling well. During this year he
developed new printing
techniques which enabled him to
produce more subtle variations of
tone and line, using different types
and cuts of wood. He also
discovered a device which enabled
him to spray soft tints on
lithographic stones. We can
deduce from its surface quality
that this lithograph benefited from
Escher's latest innovations. The
artist had recently completed a
series of prints of Rome at night,
in which he experimented with
new techniques to achieve greater
tonal variations. In *Phosphorescent
Sea*, the spatial relationship
between breaking waves and
silent night sky plays second fiddle
to his concentration on sublte
tonal gradations.

▷ Hand with Reflecting Globe

(Self-Portrait in a Spherical Mirror) 1935
Lithograph

THIS LITHOGRAPH WAS MADE soon after *Still Life with a Reflecting Globe* (November 1934) and shows Escher's growing commitment to depicting different planes on a flat surface. Our view of the room is extended through the reflection of it we see in the globe. The sitter in the picture can see the room around him, the floor and the ceiling, in fact the world held in the palm of his hand. And in the centre of the world his palm meets its own reflection and the two planes melt into one another. In the centre of both rests the sitter. Escher was making a philosophical as well as aesthetic point, for, as he said about the work, 'His head, or to be more precise the point between his eyes, comes into the absolute centre. Whichever way he turns he remains at the centre. The ego is the unshakeable core of his world.'

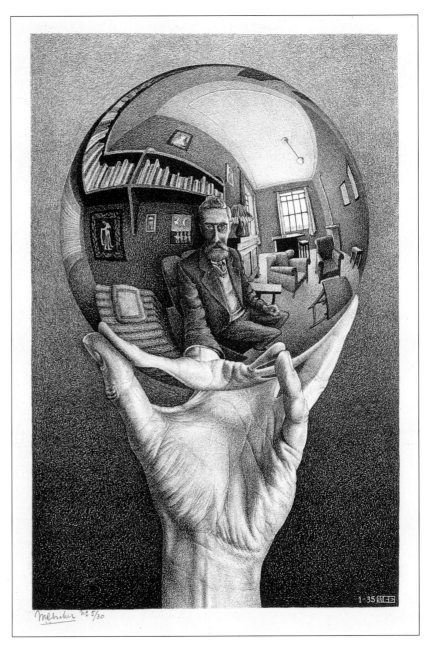

▷ **Scarabs** 1935
Wood engraving

AT TIMES, ESCHER'S ILLUSTRATIONS were close to being botanical. In *Scarabs*, he returns to a subject which had caught his attention a decade earlier, while living in Siena. There he had been witness to the arduous travails of two small dung beetles: 'The earth was mostly dark red. I saw a large beetle which was pushing a big ball (of plant fibre and earth) up the mountainside, walking backwards. The ball had a diameter of about 10 ft (3 m) The female was following her mate. Both beetles were completely black.' The image remained in his mind, to be reproduced when it best suited his creative pursuits.

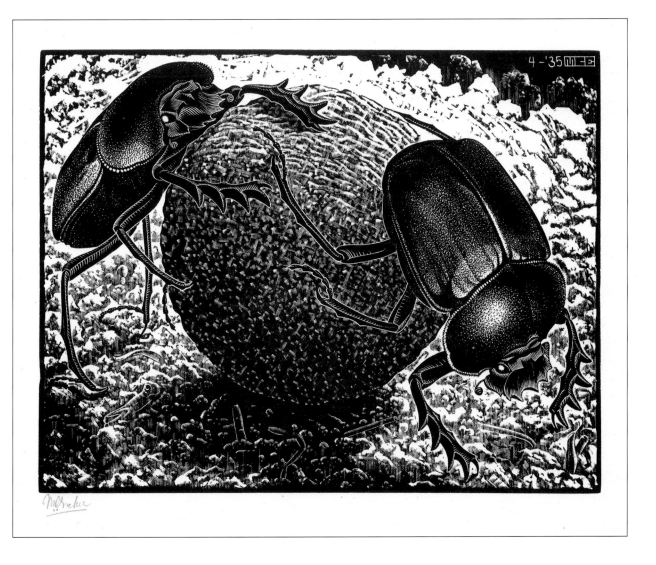

▷ **Inside St Peter's, Rome** 1935
Wood engraving

CREATED EARLY IN 1935, the high-angled aerial perspective cast a curious view into the cathedral, one which hints at Escher's later, 'impossible buildings' which seem to stand tall, when reason tells us they cannot. Escher makes the vertical lines in the image converge towards the nadir, to emphasize the height of the building and to give the viewer the sense of 'looking down' from a balcony towards the ground. 1935 marked a turning point in both Escher's professional and home life. In the spring he embarked on a long tour around Southern Italy and Sicily. The trip was inspiring but while away he received news that his son Arthur had become sick with suspected tuberculosis. Escher was advised that the Rome air was detrimental to his son's health. The family left the city in July, moving to the more healthy atmosphere of Chateau d'Oex in Switzerland. It has been suggested that Escher was also concerned to remove his family from the spread of Fascism in Italy.

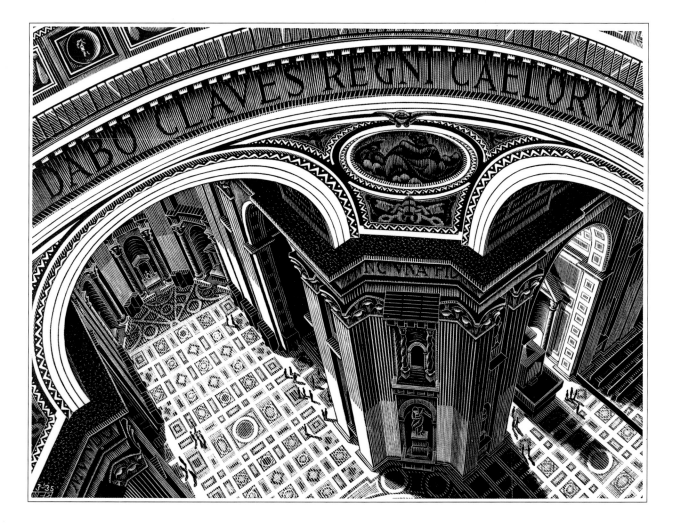

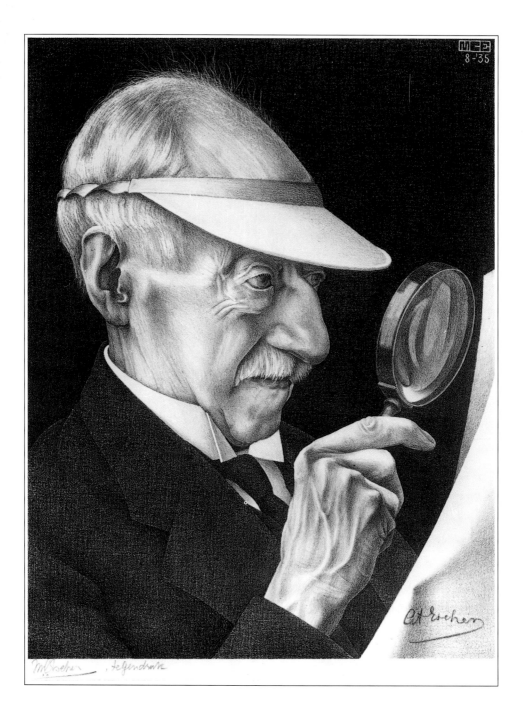

◁ **Portrait of G A Escher** 1935
Lithograph

A DRAWING MADE BY ESCHER of his father in 1916 acted as the reference for this later lithograph. The artist's fascination with the minutiae of life, of detail and perspective, were perhaps traits which he had learned from a father with similar interests. He had returned to Holland to visit his parents in July 1935 and produced the lithograph while in his father's company. Escher later wrote of the portrait, 'In the case of portraiture of someone with strongly asymmetrical features, a good deal of the likeness is lost in the print, for this is the mirror image of the original work. In this instance, a contraprint was made; that is to say, while the ink of the first print was still wet on the paper, this was printed on to a second sheet, thereby annulling the mirror image.' The 'proof' brings out the signature that he himself wrote on the stone with lithographic chalk and which is now to be seen, doubly mirrored, back in its original form.

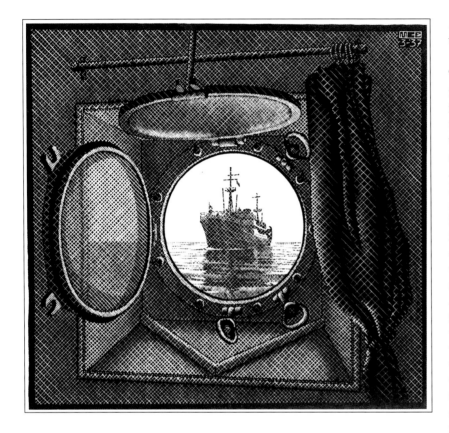

◁ **Porthole** 1937
Woodcut printed from two blocks

THE IMAGE OF ONE SHIP viewed
through the porthole of another
follows two of Escher's principal
themes – the union of different
worlds and dual perspective within
one image. As in *Hand with
Reflecting Globe*, 1935, (see page 13)
Escher uses the subject to
experiment with mathematical
ideas. The woodcut was produced
from two pieces of reference – a
drawing and a photograph. Both
were made aboard the *Rossini*. The
artist sailed free from Fiume to
Almeria on this ship in return for
some prints for the captain that he
would make along the way. His
wife joined him for part of the
voyage and they travelled on
together by train from Almeria to
Cordoba, where Escher
commented of the Moorish brick
motifs in the churches: 'This is the
richest source of inspiration that I
have ever struck.'

▷ **Still Life with a Street** 1937
Woodcut

DURING THE COUPLE'S TRAVELS, they visited the Spanish harbour town of Savona. While there, 'I discovered a picturesque old street between high houses which I drew from the first floor of a shop.' As *Porthole* (see opposite) throws open a window on to the sea, so this woodcut invites the life of the street to enter the stillness of the shop interior. The artist has manipulated perspective to enable more objects from the shop and the street to sit easily within what appears to be a representational composition. In so doing, he tricks the eye into believing in an impossible reality. The successful balance of the composition excited him: 'I felt compelled to withdraw from the direct and more-or-less true-to-life illustrating of my surroundings.' The travels in Spain up to June 1937 marked the end of such 'true to life' representations in Escher's work. From now on he would reject them in favour of his own imaginative creations, bringing to fruition those esoteric works which were to gain him international acclaim.

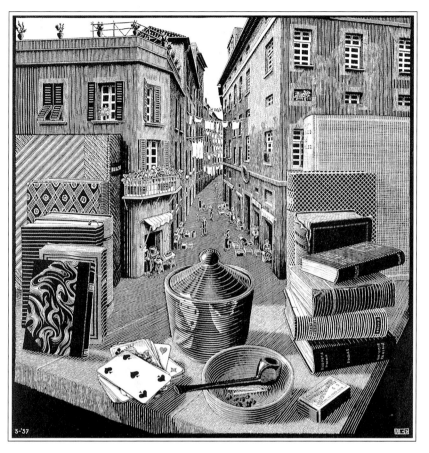

▷ **Development I** 1937
Woodcut

IN AUGUST 1937 THE ESCHERS moved to Brussels. As the year wore on, so Escher's interest in the regular divisions of the plane developed. Escher had visited his brother, a professor of crystallography, from whom he learned the term and the three theories inherent to the development of symmetry on a flat surface: repeated shifting, turning about the axis and gliding mirror image. Escher then planned images within which two-dimensional forms could literally metamorphose into three-dimensional objects. In this early example, the repeated pattern of a checked tablecloth transforms into lizards, whose bodies interlock, leaving no gaps between each of them. Although the space divided up regularly, he was not wholly satisfied with the result. He was also drawn to other references to divisions of the plane. The most influential on his work was the Moorish art he had discovered in Spain. 'The Moors…decorated walls and floors…by placing congruent, multi-coloured pieces of majolica together without leaving any spaces between. What a pity it is that Islam did not allow them to make 'graven images'.' Escher determined to take the Moorish principles and embellish them with figurative motifs.

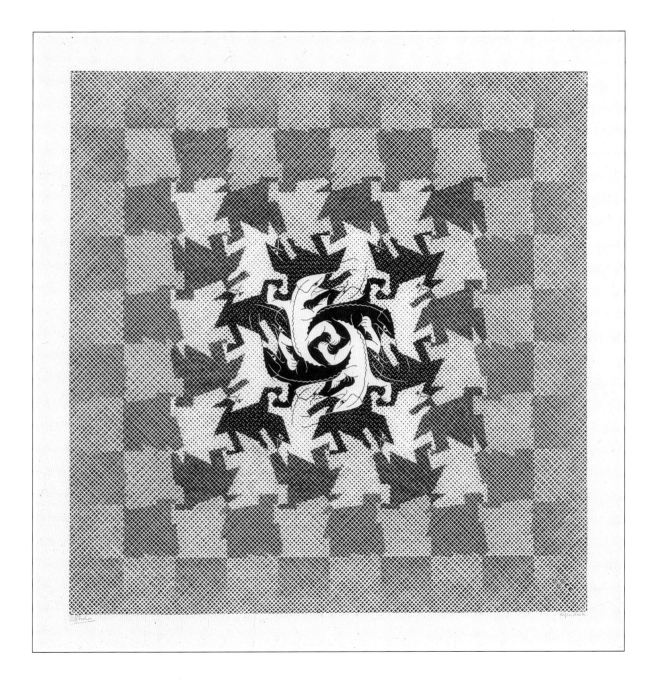

▷ **Day and Night** 1938
Woodcut printed from two blocks

DAY AND NIGHT IS ESCHER'S first full-scale transformation print. As in *Development I*, (see page 23) the rectangular shapes transform into three-dimensional objects. The fields become black and white birds which appear to exist on a new plane, flying above the patchwork of fields in the sky. The reality of the scene is impossible and yet Escher's consummate skill enables us to suspend disbelief and accept the proposed relationship between the forms. The black birds fly towards the light of day while the white birds fly into the black of night. Everything emerges out of the grey squares and there is vertical symmetry through the work.

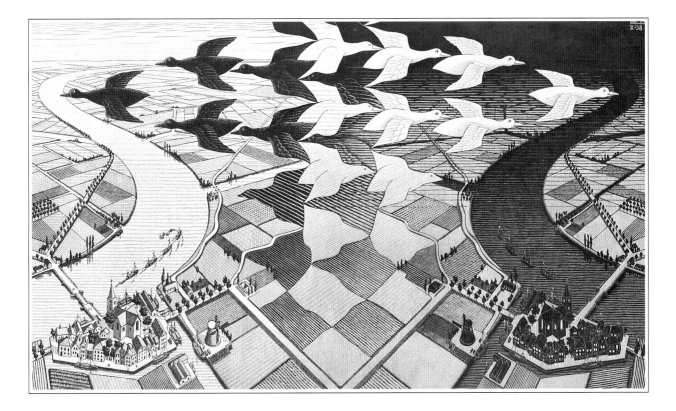

▷ **Sky and Water 1** 1938
Woodcut

AGAIN, USING GRADES of black
and white, Escher chose birds and
fish to divide up a flat surface.
The two shapes interlock and
perform dual purposes – they are
birds and fish, but become sky and
sea for one another to fly and
swim in. The subject matter
suggests evolution of the species,
as the forms develop and
transform. They co-exist only on
the middle line of the pattern.

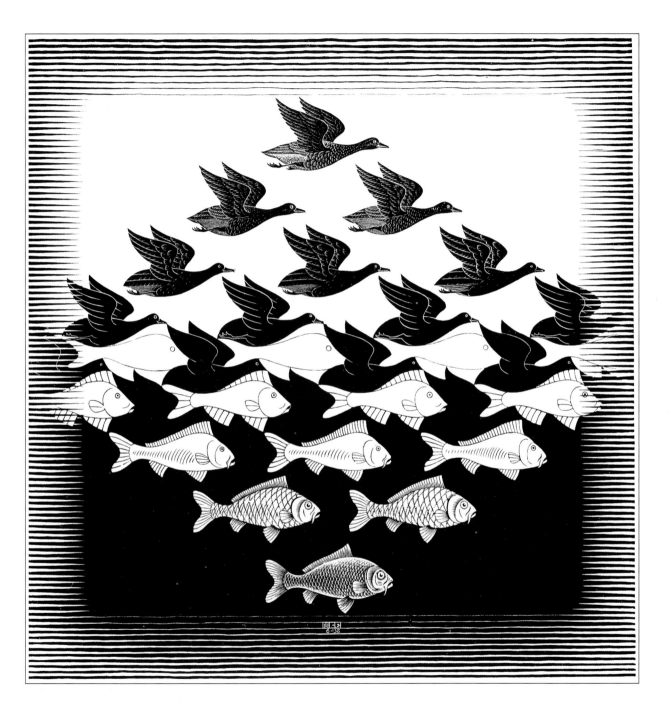

▷ **Cycle** 1938
Lithograph

THE METAMORPHOSIS WHICH takes place in this image goes through many more complex stages than in any earlier experiments with the regular division of plane. From building blocks made of three simple diamond shapes, filled in black, grey and white to suggest solid form, a pattern evolves in which the shapes slowly comes to life as comic figures running from the house. This creation of an 'impossible building' was to be developed further throughout Escher's career. The high viewpoint adds to the impression of three dimensions on the surface of the paper. During 1938 Escher's popularity grew considerably, with many public and private commissions and exhibitions. Throughout 1938 the family lived in Belgium and in March Jetta gave birth to their third child, Jan.

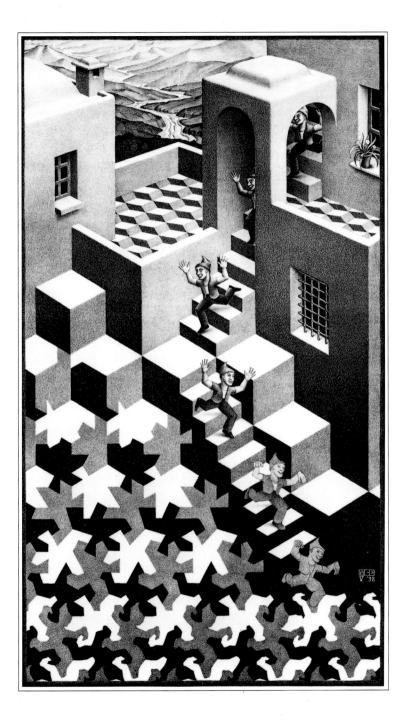

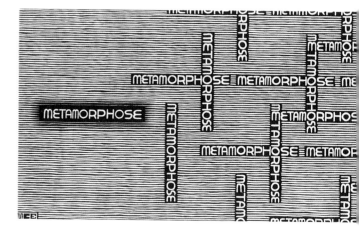

▷ **Metamorphosis II** 1939 (detail)
Lithograph

THIS ENORMOUS LITHOGRAPH, 13 ft (4 m) long, plays upon the interaction between two and three-dimensional forms throughout its metaphorical, narrative and theoretical journey. The image includes transformations from one form to another, as well as enlargements and reductions in the size of the chosen subject. Each motif is one which Escher has used in previous works – chessboards, fish, reptiles, birds and townscape. The townscape is based on a specific view of an Italian town. In the illustration, one of the buildings becomes a chess piece on a board – another direct reference, this time to Chateau d'Oex. The word 'Metamorphose' appears at the end, linking the ending back to the beginning. In this work Escher is reflecting on his past, on life in Italy and Switzerland. This period in his life was coming to a close. In 1939 his father died, and then, at the end of 1940, so did his mother. War was breaking out in Europe and Escher was unable to return from Belgium to Holland in time for her funeral. At this point he decided that he and his family should return home to the Netherlands for the duration of the war.

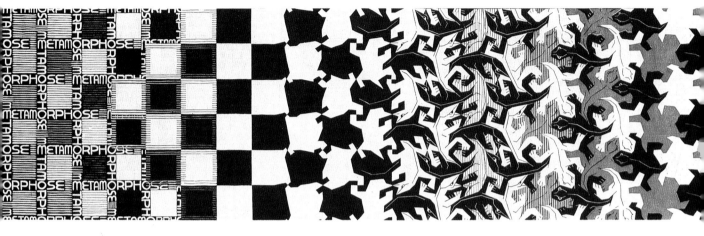

METAMORPHOSE

XI '39-III '40

▷ **Fish** 1941
Woodcut in three colours

IN THE SYMBOL OF THE FISH
Escher found infinite possibilities
opening up to him. It could be
manipulated to interlock with itself
perfectly, *ad infinitum*. By slowly
reducing its scale as he worked, he
could take it to a successful
vanishing point. For this woodcut,
unusually, Escher employed three
colours, to help define the
elaborate pattern he was creating.
Around this time, the artist
established a home for his family
in the small village of Baarn in
Holland. He was able to work
there throughout the war, with
little interference.

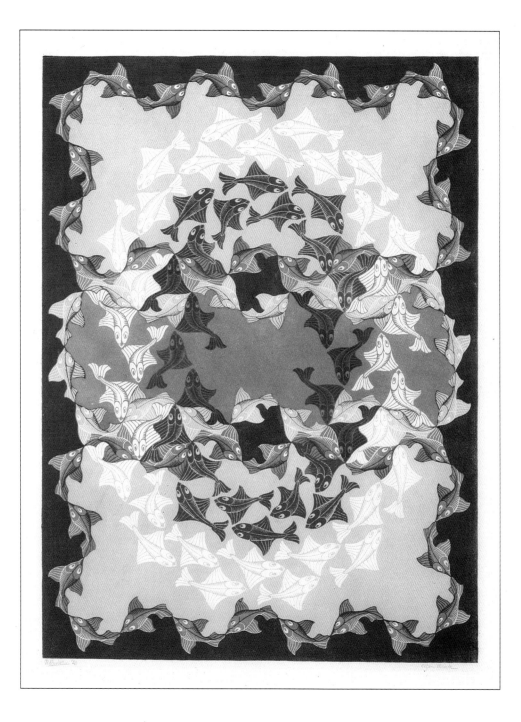

▷ **Verbum** 1942
Lithograph

ESCHER CHOSE THE TITLE *Verbum* for its association with the story of the creation. No one element within the composition dominates. Escher wanted to encourage the eye to move undirected from the centre of the image which one is accustomed to perceiving as its heart. In this example it is grey and abstract, in contrast to the rest of the image which becomes more vivid and tonally contrasting as it extends towards the margins. Escher had been battling with the problem of how to repeat motifs to the point of infinity. By starting at the centre he discovered that the image could spread outwards into a far greater spatial arena – the repeated shapes transforming into birds, fish and frogs, which disappear into air, water and earth.

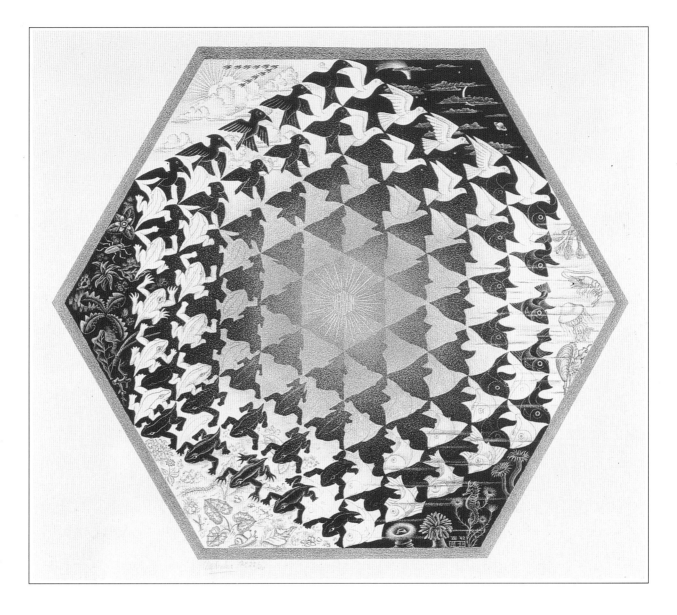

▷ **Reptiles** 1943
Lithograph

REPTILES IS ONE OF ESCHER'S most celebrated images: expounding his theories clearly while providing a great source of entertainment for the viewer. A drawing of reptiles, successfully interlocking to fill the two-dimensional plane, is disrupted by the apparent 'escape' of one of its number, in the bottom left-hand corner of the sketchpad. We follow this reptile as 'life', or in artistic terms, 'the third dimension' is breathed into it and it takes on a new, and apparently more liberated character. Escher was obviously charmed by his creation and described it colourfully: 'With one plastic-looking leg over the edge of the book, he wrestles himself free and launches out into real life. He climbs up the back of the book on zoology and works his way laboriously up the slippery slope of a set square to the highest point of his existence. Then, after a quick snort, tired but fulfilled, he goes downhill via an ashtray.'

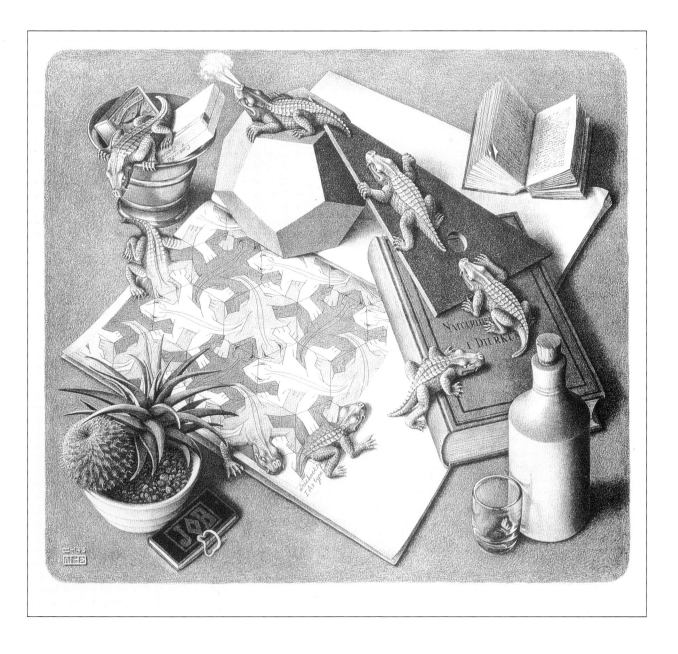

▷ **Encounter** 1944
Lithograph

IN THIS STRANGE, POSSIBLY
subterranean world, the black and
white figures begin as imprints or
shadows upon a wall. But then
they take on more solid forms and
begin to move and dance around
in a circle on a flat floor surface.
The shadows on the wall appear
to continue down into the circular
void around which the figures
dance. The white men are fully
formed, in contrast to the semi-
developed bodies of their black
counterparts. Escher called them
symbols of optimism (white) and
pessimism (black). In 1944, his
great friend and teacher, the
Jewish De Mesquita, was taken
away by the Germans. Escher was
never to see him again. The
disappearance of his mentor
greatly distressed the artist who,
once the war was over, arranged a
memorial service at which he paid
tribute to De Mesquita's artistic
skills and influence.

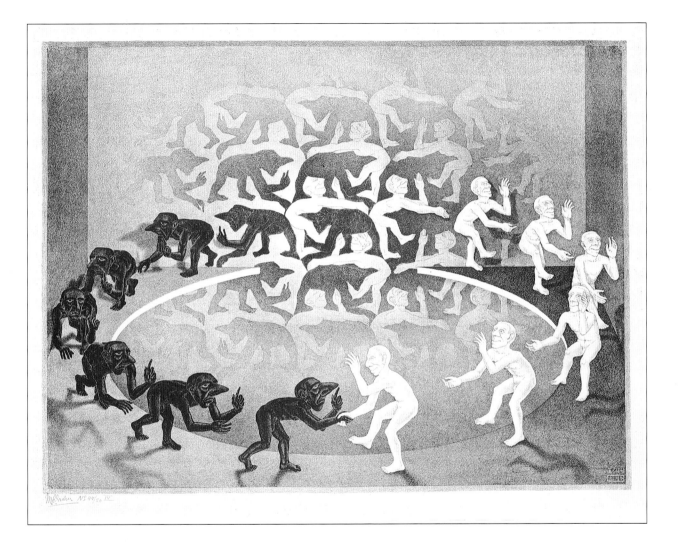

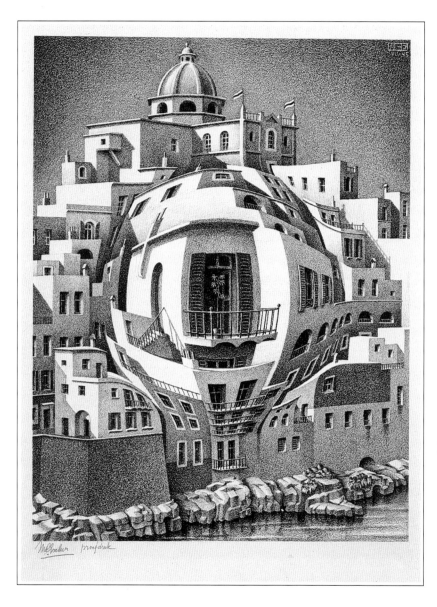

◁ **Balcony** 1945
Lithograph

ESCHER MADE MANY TRIPS to
Malta throughout his life and was
always inspired by the view of the
city's harbour as seen from the
ship on arrival. In *Balcony* he has
'blown up' a building in the centre
of the townscape so that it may be
more closely examined. We think
of the whole townscape as being
three-dimensional, and yet this
'bulge' flattens all the buildings
again. The balcony appears to
have been filled with air from
behind, and forced to swell out
like a balloon. Some critics have
commented upon the central
importance of the plant sitting on
the balcony – a mild
hallucinogenic which would
enable one to see the world as
imaginatively as its creator,
perhaps? Escher did not read such
'psycho-babble' into his scene,
preferring to describe it, 'simply as
an expansion'.

△ **Magic Mirror** 1946
Lithograph

THE MIRROR WAS THE PERFECT motif through which Escher could open up a view on any new or imagined world. In this instance, a strange beast is born within the mirror's glass. Characteristically for an Escher creation it leaves its birthplace and moves around the table top. Eventually it becomes flattened and fades into the surface pattern. Escher enjoyed creating images in which the world of the imagination appeared to 'come to life'. The creature creeps around the back of the mirror. Its existence there makes us wonder whether it has managed to escape from Escher, like the lizards in *Reptile* (see page 38), and create its own world outside his mind.

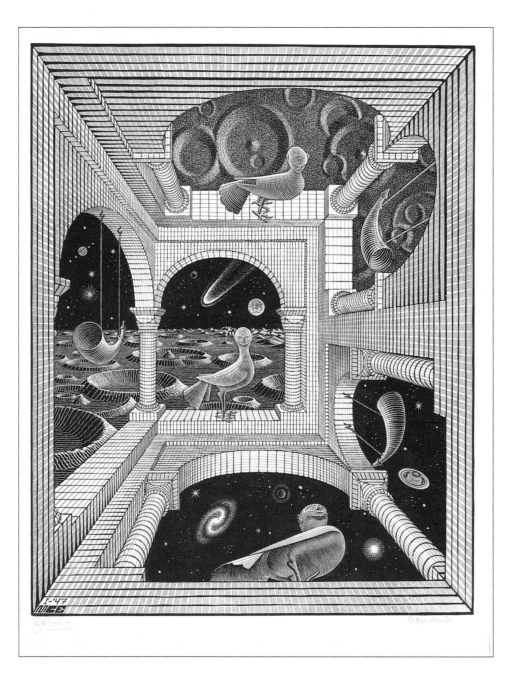

◁ **Other World** 1946
Wood engraving and woodcut
from three blocks

ESCHER CATEGORIZED THIS image
within a group which
concentrated on multiple
perspectives. He stated that before
the birth of photography, most
artists followed the Renaissance
principles that perspective was
linked to the position of the
horizon line, and, on the vertical,
to the nadir and the zenith. As a
result, the illusion of depth could
be created by using parallel lines.
Escher liked to adapt these
principles, producing multiple
views and more than one
vanishing point within a single
image. This picture is a good
example of his experiments in this
field. From the interior of the
cube, windows open out onto
three different landscapes, each
apparently seen from a new
perspective. Out of the top two
windows one looks down towards
the ground, from the middle two
one can see the horizon at eye
level, and from the bottom two,
one looks directly up from
underneath the stars.

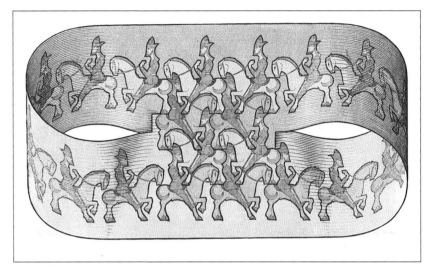

△ **Horseman** 1946
Woodcut printed from three blocks

ESCHER'S UNDERSTANDING OF
weaving techniques is manifest in
this work. The horsemen are
portrayed on a fabric-like 'band'.
On the outer surface their tone is
dark and strong. On the inner
surface, or the 'back' of the fabric,
they are far paler, where on a
fabric the reverse of the weave
would be shown. Where the pale
horsemen meet the darker ones,
the front and back of the band
merge, as do the figures, until, in
the centre of the image, one can
no longer tell which is which, or
where one side ends and the
other begins.

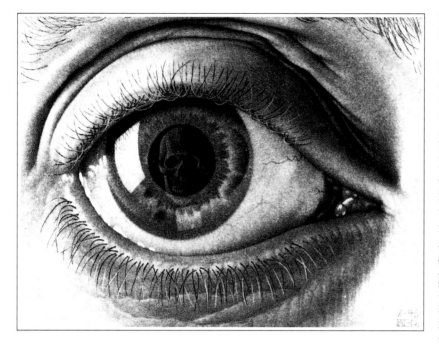

△ **Eye** 1946
Mezzotint

IN 1946 ESCHER EXPERIMENTED with the complicated and lengthy printing process known as mezzotint. He found that he could achieve the most subtle variations of light and dark tone within one image when using the method. It took eight stages for this image of an eye to evolve from initial drawing to final print. The image is of the artist's own eye, studied and drawn from a concave shaving mirror. Deep inside the eye one can perceive the shadowy and sinister form of a skull.

▷ **Crystal** 1947
Mezzotint second state

SENT AS A NEW YEAR'S card to his sister, *Crystal* is so-called because, as Escher wrote to her, '*Order and Chaos* sound too ponderous, although that title actually gives a better indication of my intention. Let me add that Chaos is present everywhere, in countless ways and forms, while Order remains an unobtainable ideal: the magnificent fusion of a cube and an octahedron does not exist.' But, of course, in Escher's work, for his pleasure, it did. During the latter half of the 1940s Escher's following grew rapidly and he found that he was spending more time organizing exhibitions of his work and giving lectures, than in the creation of new prints. Theory was taking up far more of his time than practice.

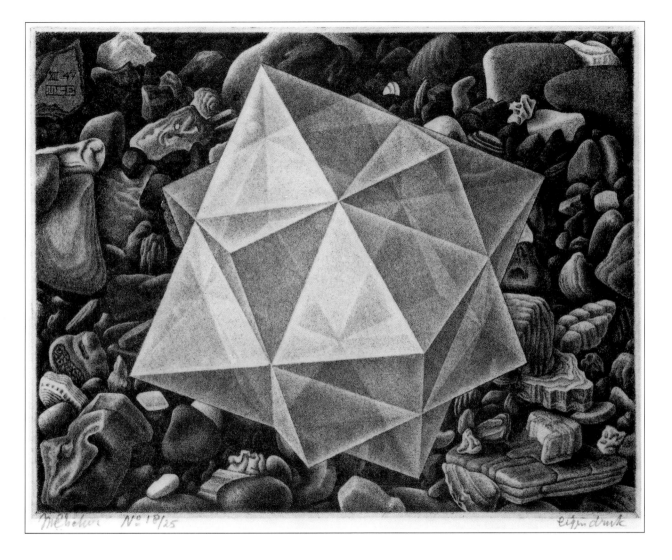

Escher No 18/25 eigendruk

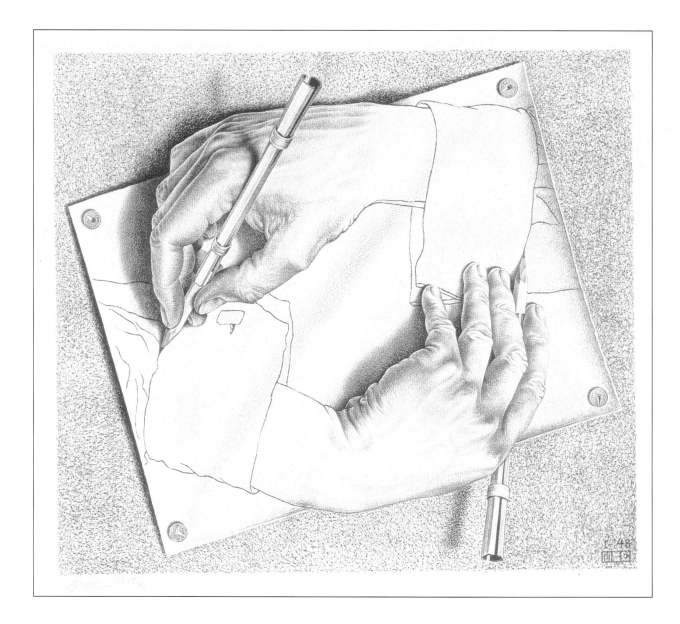

◁ **Drawing Hands** 1948
Lithograph

HERE ESCHER PROVIDES US with
the ultimate three-tiered visual
conceit. We are shown a drawing
of a hand, drawing a hand,
drawing a hand. The image gave
Escher another platform for his
exploration of the relationship
between two and three-
dimensional image. He argued
that we are trained to perceive
things around as one or the other.
A wall, or a flat piece of paper, for
example, are two-dimensional,
whereas a pencil or a hand are
three. In this picture the
boundaries between the two are
blurred, and the viewer is forced
to decide where one ends and the
other begins. It is interesting that
Escher chose to depict a left hand
drawing a right hand, as he
himself was left-handed. In 1952,
from superficial researches, he
suggested that left-handed artists
might be more likely to take an
interest in drawing and the
representation of forms than
right-handed artists, who were
more naturally inclined to
painting with colour.

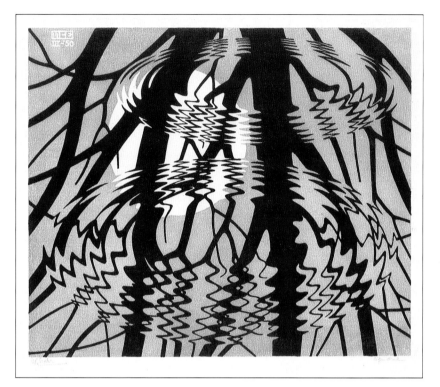

△ **Rippled Surface** 1950
Linocut from two blocks

REFLECTIONS IN WATER were
another regular source of
inspiration for Escher. The
refraction of an image, and its
reflection in the surface of a
volume of water offered him new
scope for spatial experiments. He
was fascinated by the ability of
one or two drops of water to
create a ripple effect which could
extend outwards from its centre
and trigger a whole train of
transformations, both in the
surface of the water and the
subjects which were reflected in
it. Here, the suggestion of depth
in the transparent volume of
water is suggested only in the
effect of the ripples.

▷ **House of Stairs** 1951
Lithograph

IN 1951 ARTICLES ON ESCHER'S work were published in both *Time* and *Life* magazines and favourable reviews appeared in various other foreign journals. *House of Stairs* shows progression in his experiments with multiple perspective, or as he described it, 'the concept of relativity'. The stairwell in the house can be divided horizontally along the central axis of the image – the bottom half is repeated. The sense of ascent and descent cancel one another out, for the creatures drawn into the image are able to perform both activities on the same stairs. This is another example of an 'impossible building'.

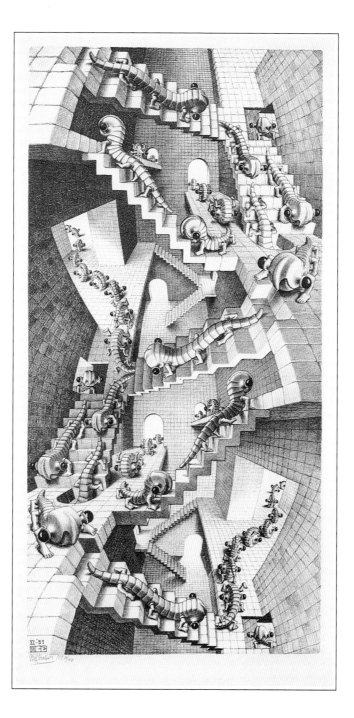

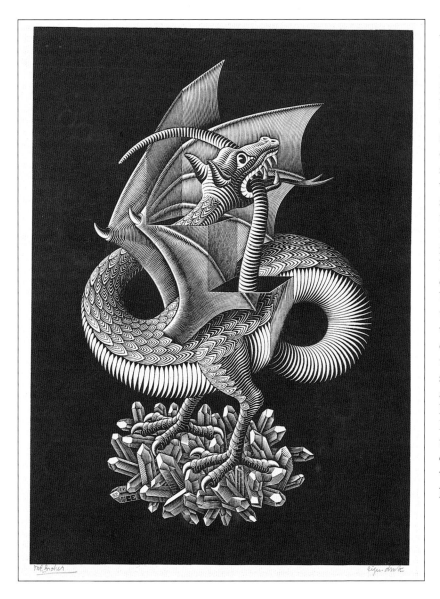

◁ **Dragon** 1952
Wood engraving

ESCHER AGAIN EMPHASIZED the
irrational distinctions we make
between two and three-
dimensional planes on the flat
surface of paper. But on this
occasion he takes the concept a
stage further, by using one object
which exists as both a flat and
solid form simultaneously. Unlike
the earlier work, *Reptiles* (see page
38), in which the flat lizard evolves
into a solid body and then settles
back into the flat pattern, here the
creature exists simultaneously in
both forms. Escher emphasizes the
two-dimensional qualities of the
whole image, although parts of the
creature's anatomy are drawn in
three dimensions. The dragon
sticks his head through his wing
and his tail through his body, yet
he remains 'flat' on the paper.
Escher is intentionally labouring
the point to make the viewer
confront the literal reality – that
we are looking at a print on a flat
piece of paper.

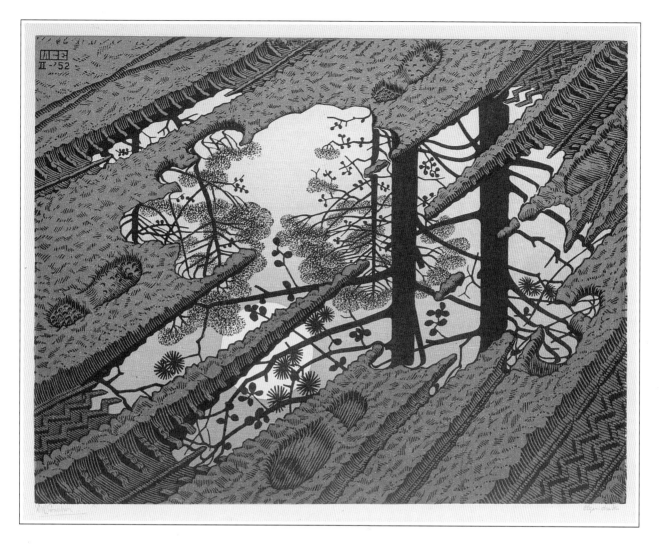

△ **Puddle** 1952
Woodcut from three blocks

THE REFLECTION OF SKY above water is here shown in a purely flat surface, with no ripples refracting the reflected image. Escher is developing the theme first explored in *Rippled Surface* (see page 49), but because he leaves the water clear and flat, it is only from the surrounding tyre, bicycle and feet marks in the mud that we can see that we are indeed looking into water. Without these clues, it would appear that we were looking through a broken windowpane into another world below.

▷ **Relativity** 1953
Lithograph

NO LONGER SATISFIED BY CREATING ambiguity in the direction of the stairwells alone, in *Relativity* the whole room is spinning on a central axis, producing three earth-planes. People move around in each plane, within their own gravities. On one of the stairwells two figures are moving, one using the stairs to walk up, the other to go down. They seem completely unaware and untouched by one another's presence. The quality achieved has surreal overtones – each element within the picture living within its own spatial realm.

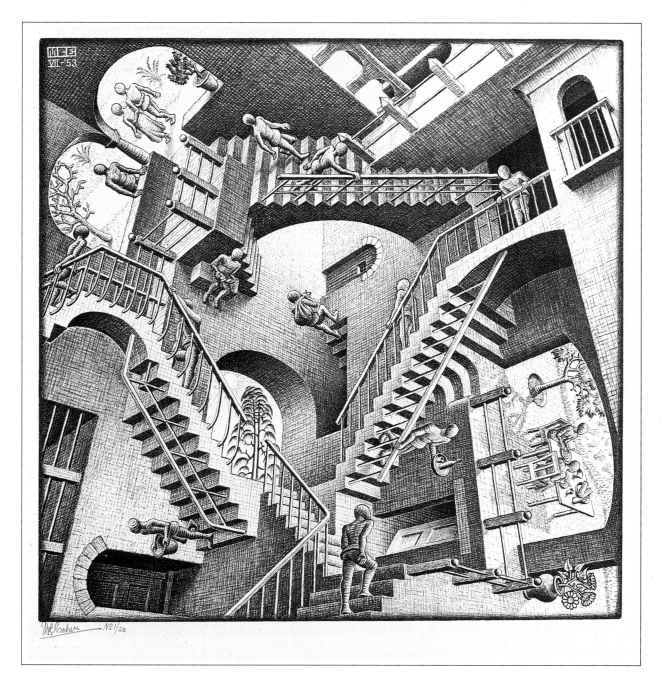

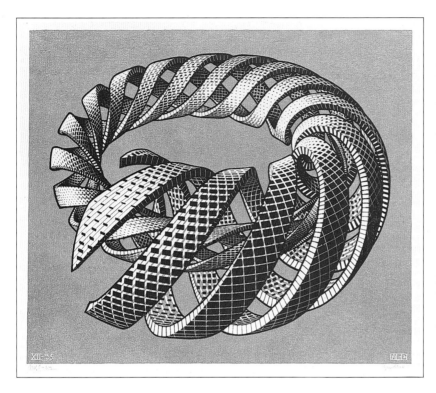

▷ **Convex and Concave** 1955
Lithograph

IN THE EARLIER PRINt, *Cycle*, 1938 (see page 28), Escher confronts the difficult relationship between convex and concave shapes – when we look at a cube, for example, do we see the internal or external structure? Here he takes the problem a stage further, showing us a block of three interconnecting houses. The first house, to the left, offers views out of a window on to the street. The third shows a man climbing a ladder, apparently on the outside wall of the building. The central house, however, confuses us. Are we looking inside or out? Can we trust what our eyes are telling us?

△ **Spirals** 1953
Wood engraving, printed from two blocks

'FOUR SPIRALLING STRIPS come together to form a curved casing which, as a narrowing torus, returns to the place where it began, penetrates within itself and starts on its second round.' The concepts which went into the creation of *Dragon* (see page 52) are now taken into an abstract form. Although 1953 was a successful year for Escher, he found that he was forced to pass many hours organizing shows. During the following year, he only made two prints, as most of his time was spent in the USA, where he held his first one-man show. This was such a success that it forced him to raise the price of his prints to slow down demand, but this seemed to make little difference, and Escher was under constant pressure to provide more pictures for his growing audience.

▷ **Depth** 1955
Wood engraving and woodcut printed from
three blocks

THE REGULAR DIVISION OF the plane is taken into three dimensions in this image. Escher repeats the motif of the shark – which appears more like a mechanical flying machine than an animate mammal, creating the illusion of extraordinary volume on the picture surface. The motifs overlap and decrease in size as they recede away from our view.

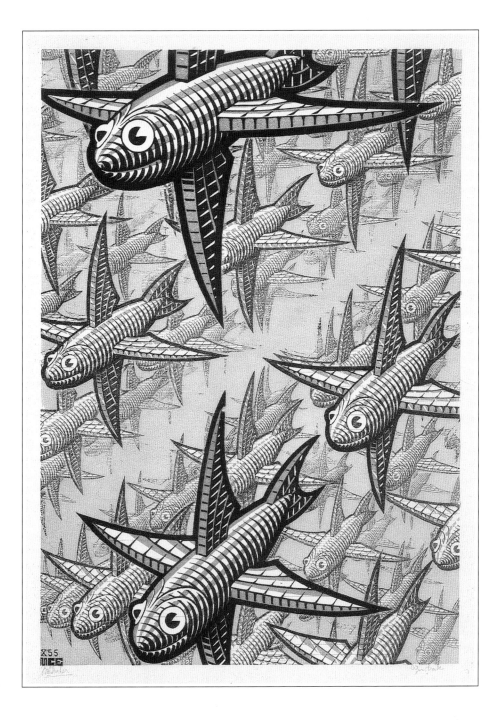

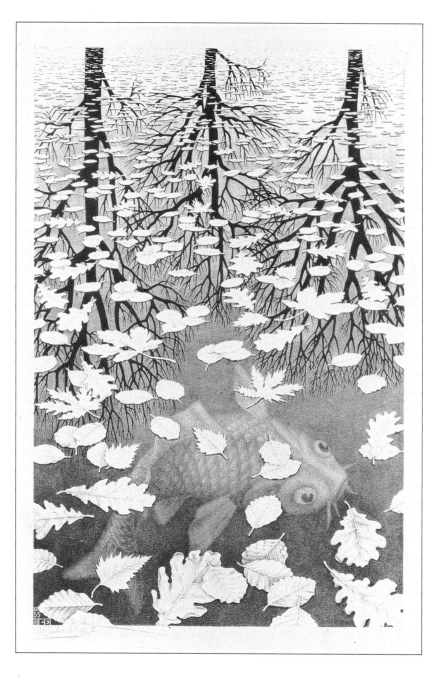

◁ **Three Worlds** 1955
Lithograph

A PARTICULARLY BEAUTIFUL and
simple image, the print shows
three worlds linked by the
reflective surface of the water. The
trees which tower above and
outside of the picture plane are
only viewed by their reflected
shapes. Their leaves sit on top of
the water, blocking out any
reflections which would be
apparent were they suspended
above its surface. The fish lying
beneath the surface draws us into
the depths of clear water.

▷ **Print Gallery** 1956
Lithograph

THIS IMAGE CONVEYS many of the characteristic features of Escher's mature work. It is cyclic, and includes elements of magnification and transformation, as well as internal and external perspectives. By following the designated route through the door of the print gallery, up into the exhibition space above, we meet a boy who is studying the first picture. If we follow his gaze, we find ourselves being drawn into a 'second' artwork and through it, into the harbour which exists outside the print gallery. Once there, Escher transforms the image again, enfolding the gallery itself into the confines of the print. The whole image implodes and the viewer is left on uncertain and confusing ground. Paradoxically, the boy viewing the print on the gallery wall now appears to be as much a part of it as any other element within it. Escher's world is becoming more sophisticated and demanding of our perceptions all the time.

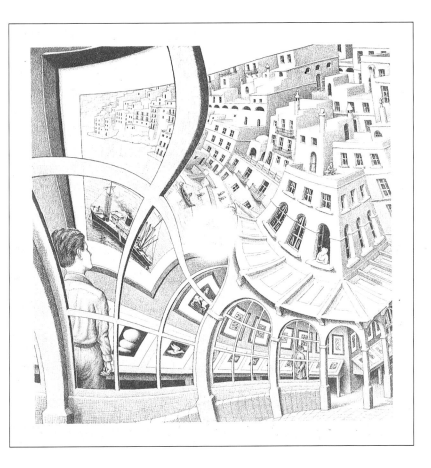

▷ **Smaller and Smaller 1** 1956
Wood engraving and woodcut from four blocks

ALTHOUGH ESCHER WAS STIMULATED by creating tessellations (pavings of tiles) of one form so that they interlocked and regularly filled a single plane, he wanted to continue developing the idea into further dimensions. By reducing the size of the motif he selected each time, it would appear to diminish into infinity. In this wood engraving, the motif of the reptile is repeatedly halved in size as it is repeated towards the centre of the image. Escher felt that the image had only partially succeeded, for the outer edge is arbitrary, rendering the image incomplete.

◁ **Whirlpools** 1957
Wood engraving and woodcut
printed from two blocks

THE CHARACTERISTIC MOTIF of
fish is used here to repeat the
exercise practised in *Smaller and
Smaller 1* (see page 62) with
different-shaped symbols. The
white fish swim clockwise, the
black anti-clockwise, each filling
the empty spaces left by the other.

▷ **Belvedere** 1958
Lithograph

THE PIECE OF PAPER FALLEN to the ground on the terrace poses the question, which side of the cube is the front, and which the back? Of course, either answer is correct, and no one in the picture seems the slightest bit concerned by the issue. The boy seated on the bench is considering the nature of another cuboid resting in his hands, unaware that the paradox he holds is also present in the piece of paper on the ground and in the structure of the building right behind him. We can see the interior of the first floor, but as the two men climb up the ladder to the second floor, they find that they are now standing outside. They must clamber back into the building by climbing over a balcony wall. The world is beginning to appear unstable.

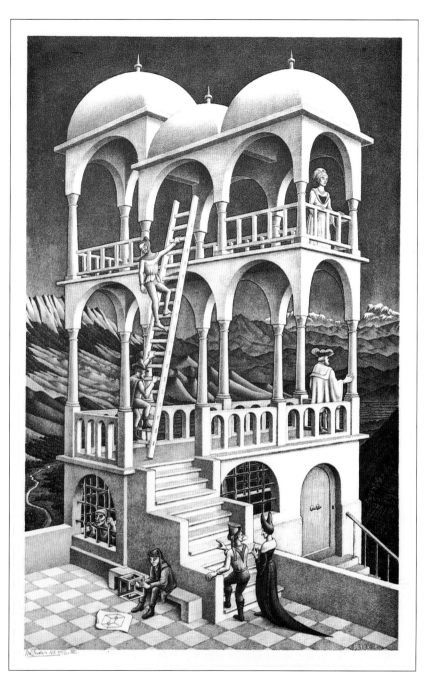

▷ **Circle Limit III** 1959
Woodcut from five blocks

BY USING A CIRCULAR composition
and five colours, Escher was able
at last to create an image where
the regular division of the plane
and the appearance of infinity
united flawlessly. The use of white
curved lines to divide up sections
of the image also emphasizes its
curved surface so that it seems as
if we are looking at one side of a
ball, hence our brain tells us that
the image continues outside of our
range of vision, all the way around
its diameter.

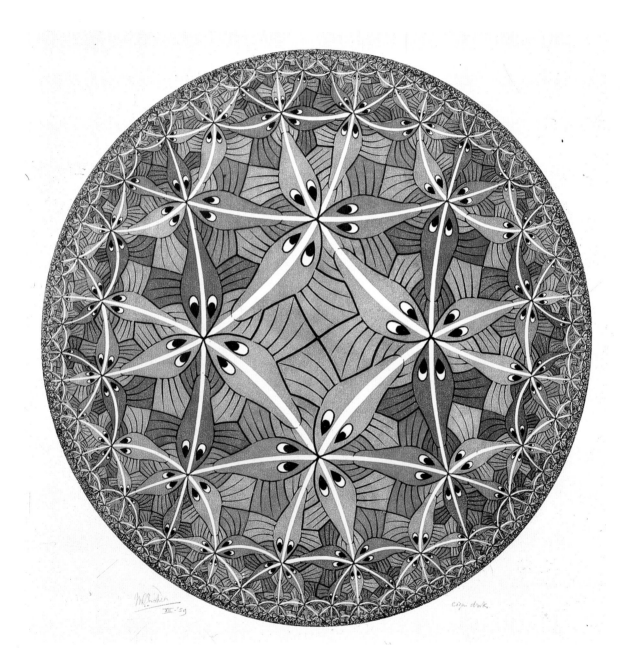

▷ **Fish and Scales** 1959
Woodcut

BOTH WHOLE FISH AND DETAILS of their heads and scales are repeated in this image. Escher has extended his practice of reducing repeated motifs in this print by taking details from the motifs and integrating them into the image, developing a more elaborate pattern. The process in the top half of the image evolves across the paper from right to left. The same design is repeated in the bottom half of the paper, but, in contrast, from left to right.

▷ **Circle Limit IV (Heaven and Hell)** 1960
Woodcut from two blocks

TWO NEW MOTIFS APPEAR in *Circle Limit IV*, devils and angels. As in *Circle Limit III* of the previous year, Escher is exploring methods of depicting infinity. The three large white angels and black devils in the centre of the image evolve outwards as smaller replicas, creating an attractive circular pattern. The pattern is divided into six sections, the angels or the devils dominating alternately. Where the black devils take precedence it appears that they are flying across a white background. Where the angels stand out, it is against a black background.

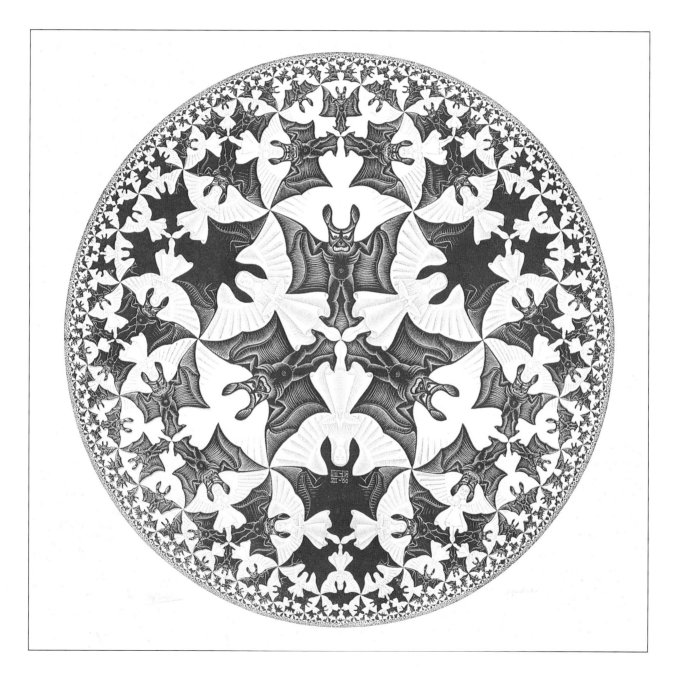

▷ **Ascending and Descending** 1960
Lithograph

THE FIGURES WALK AROUND the upper courtyard, as if performing a ritual, like monks or prison inmates taking their daily exercise. It appears that they may walk either clockwise or anti-clockwise, and up the stairs or down. The point of the exercise seems to be missing. There are two isolated figures who do not partake in this peculiar and seemingly endless practice. Escher gained the idea for this work from an article he had read by LS and R Penrose in the *British Journal of Psychology*.

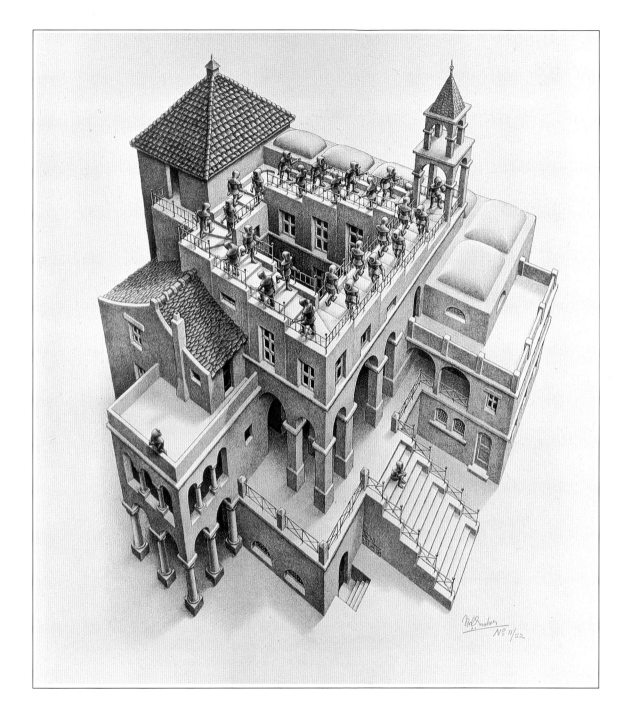

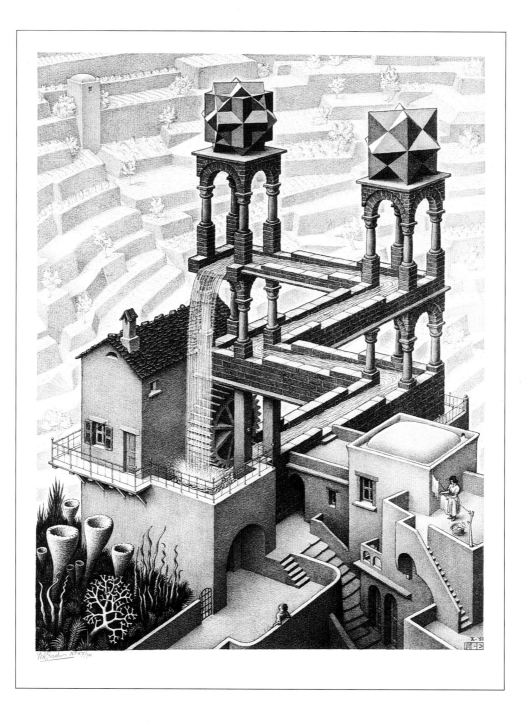

◁ **Waterfall** 1961
Lithograph

ANOTHER ARTICLE PUBLISHED by R Penrose in the *British Journal of Psychology* sparked Escher's experiments in *Waterfall*. A diagram of a triangle was published alongside the article. Escher was fascinated by it and reproduced its form three times within this image. Although our eye can lead us through the building, from the bottom to the top without encountering any diversion, the construction is flawed. The two towers appear to be the same height, but the one positioned to the right rests a storey lower than the one to the left.

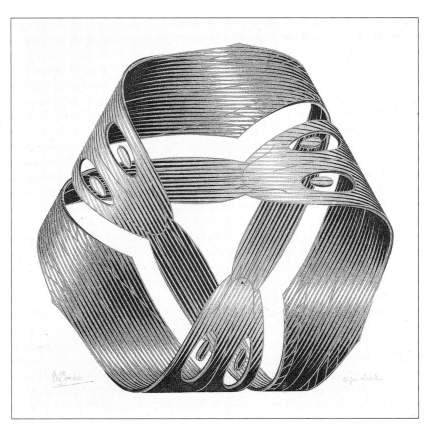

△ **Moebius Strip I** 1961
Wood engraving and woodcut from four blocks

THIS IS ANOTHER EXAMPLE of Escher's experiments with 'unlimited spaces' which appear to have no beginning, middle or end. In *Moebius Strip I*, an endless band has been split down its length into two pieces. They have then been divided and although they should fall apart, it appears that they are still joined together. Escher described them as 'three fishes, each biting the tail of the one in front'.

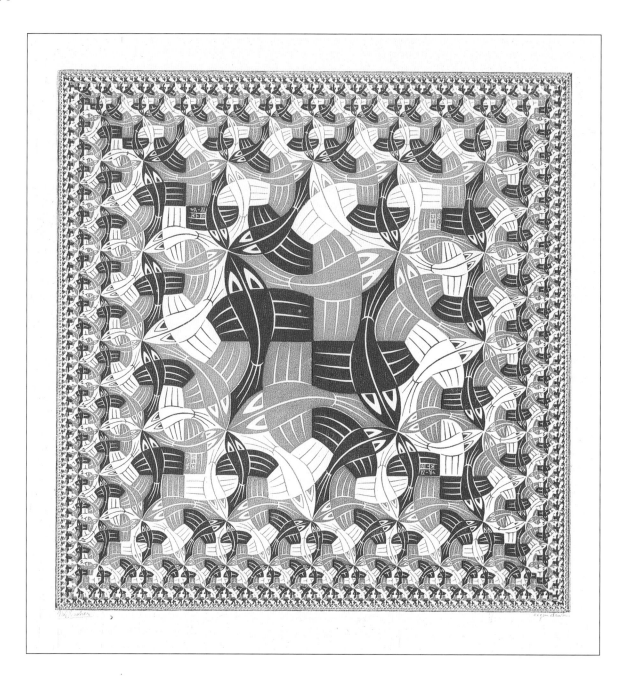

◁ **Square Limit** 1964
Woodcut printed from 2 blocks

As in Escher's earlier circular spatial experiments, the point of departure for the pattern in *Square Limit* is the centre. The pattern develops outwards, the repeated fish motif diminishing as it spreads toward the margins of the image. The motif is halved each time it is repeated. During 1964 Escher's health was beginning to fail him. He had been admitted to hospital in 1962 and it had taken him until now to recover. He did not produce much work during this time. In October 1964, Escher and Jetta travelled together to Canada where the artist was again taken ill and hospitalized.

Snakes 1969
Woodcut printed from three blocks

▷ *Overleaf page 78*

Snakes was Escher's last published print. He was pleased with the result, although he admitted in a letter to friends that it had been a struggle: 'I don't imagine that this will be a masterpiece…but I am extremely satisfied because my hand doesn't shake at all and my eyes are still good enough for such precision work.' He had used a magnifying glass, lit up by a neon tube, to help him to see and achieve the fine details. Soon after finishing *Snakes*, Escher moved alone into an artist's colony called the Rosa Spier House in Laren. Sadly, Jetta had left him the year before and returned to live in her native Switzerland. There was medical care at the colony for Escher, as well as studio space where he could work, so he was very happy there. But the artist's health deteriorated further over the following 12 months, and he died, at the age of 73 in March 1972.

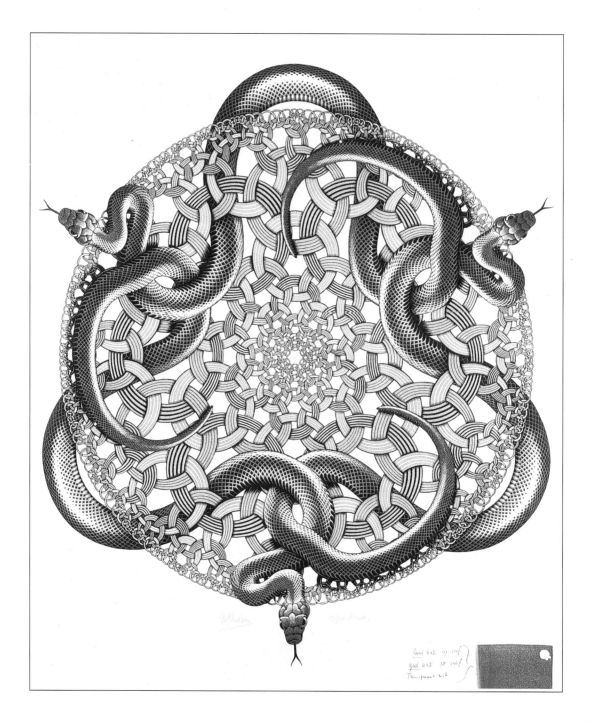